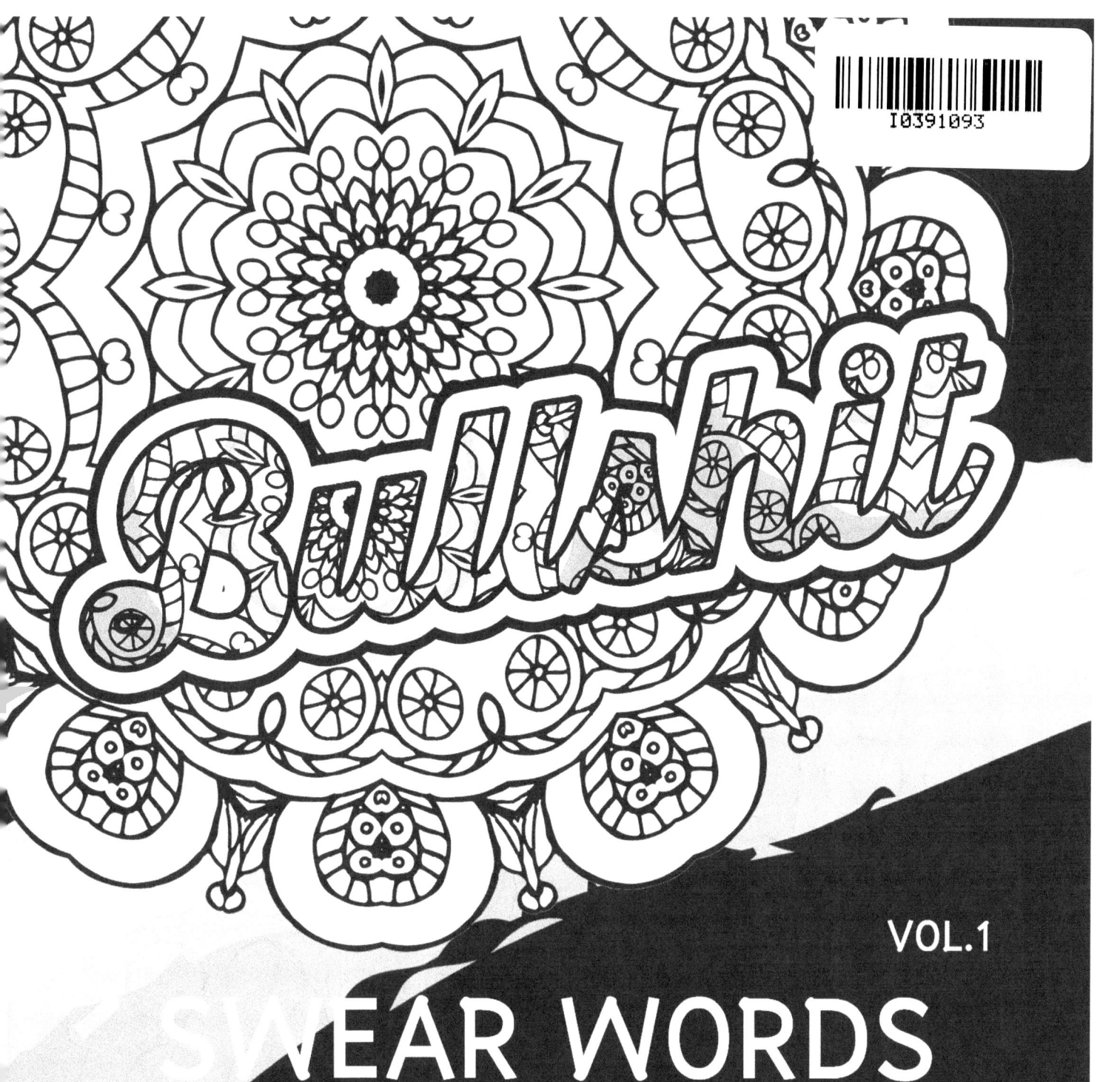

SWEAR WORDS
COLORING BOOK

VOL.1

Mandala Coloring Books for Relaxation
Meditation and Creativity

COLOR TEST PAGE

COLOR TEST PAGE

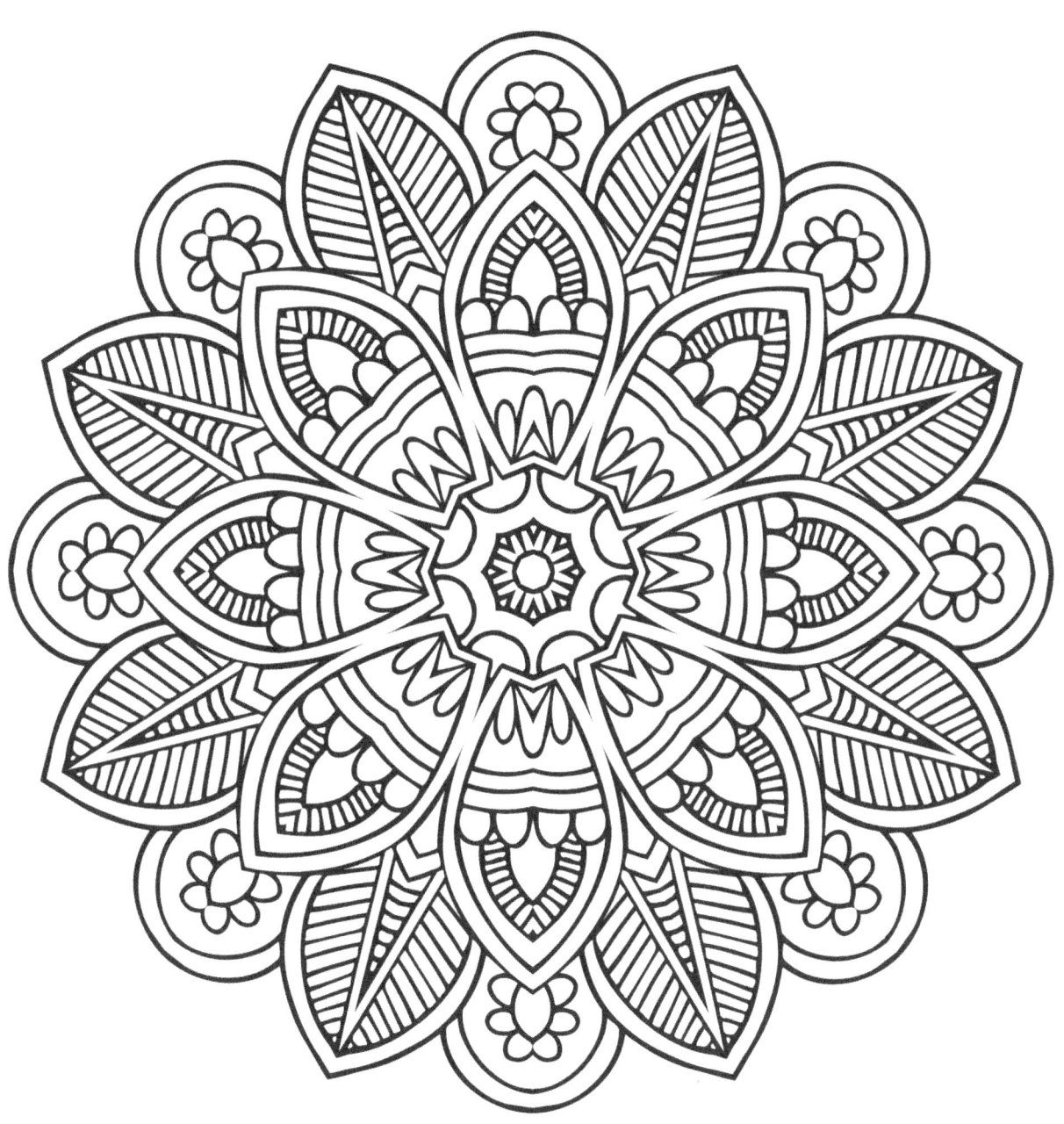

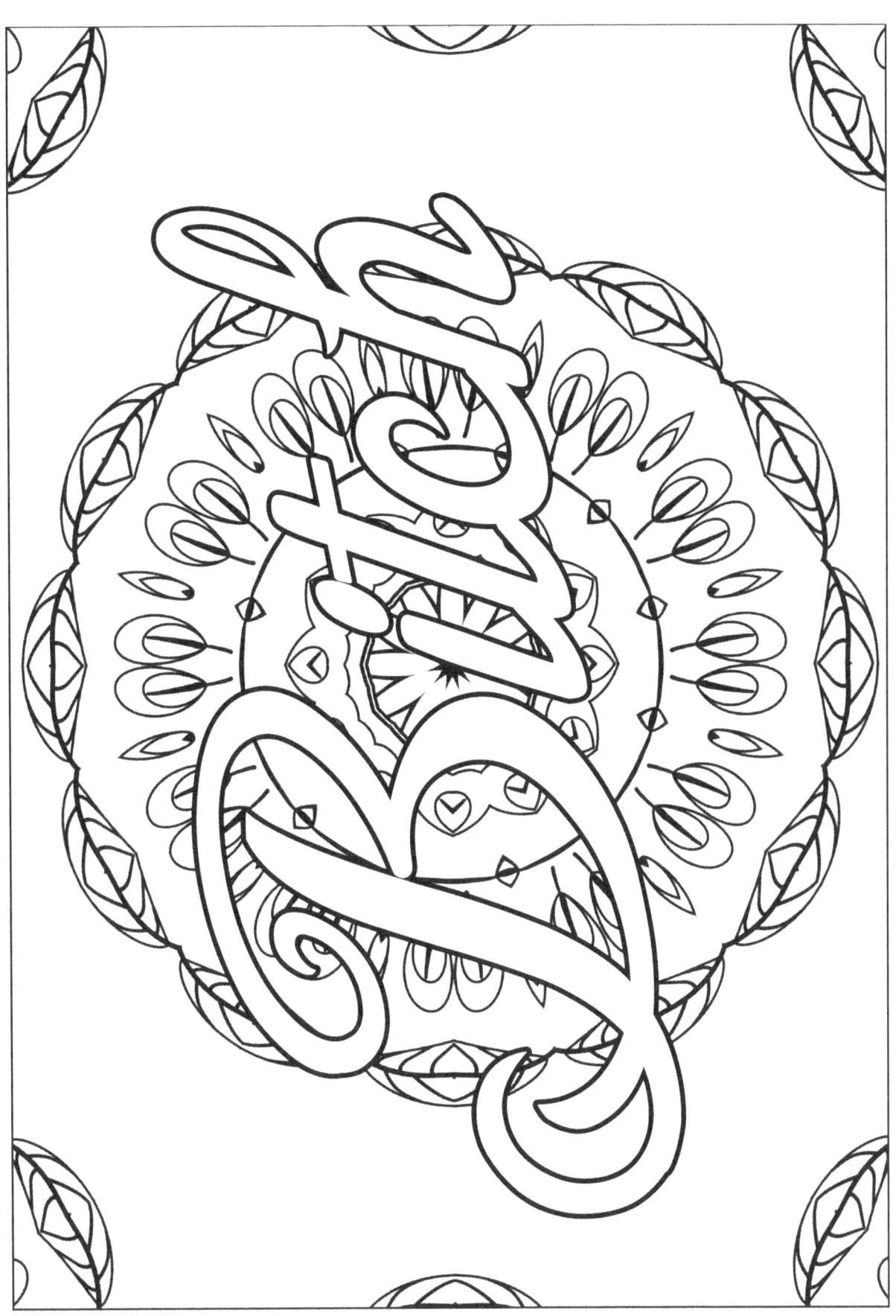

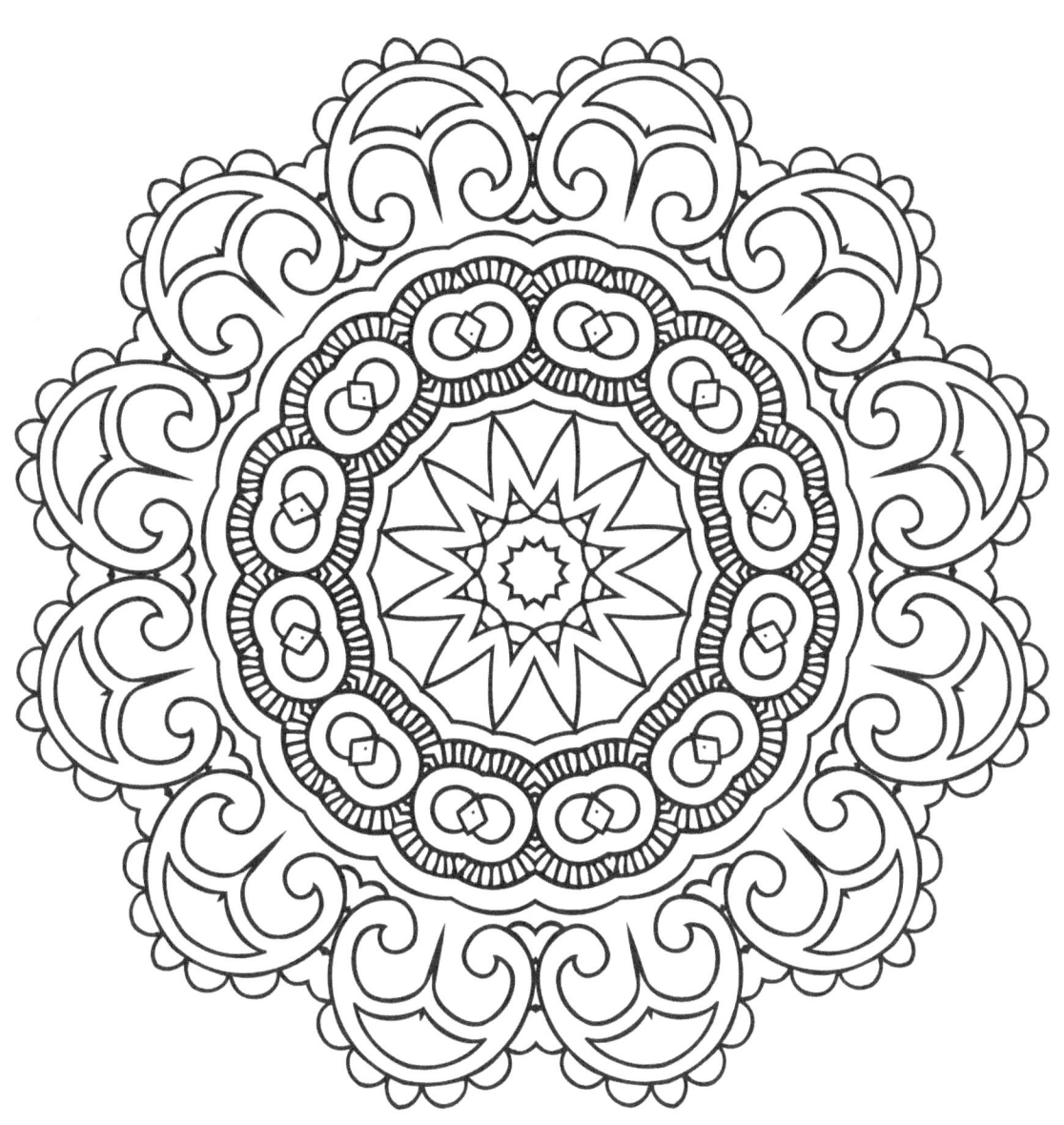

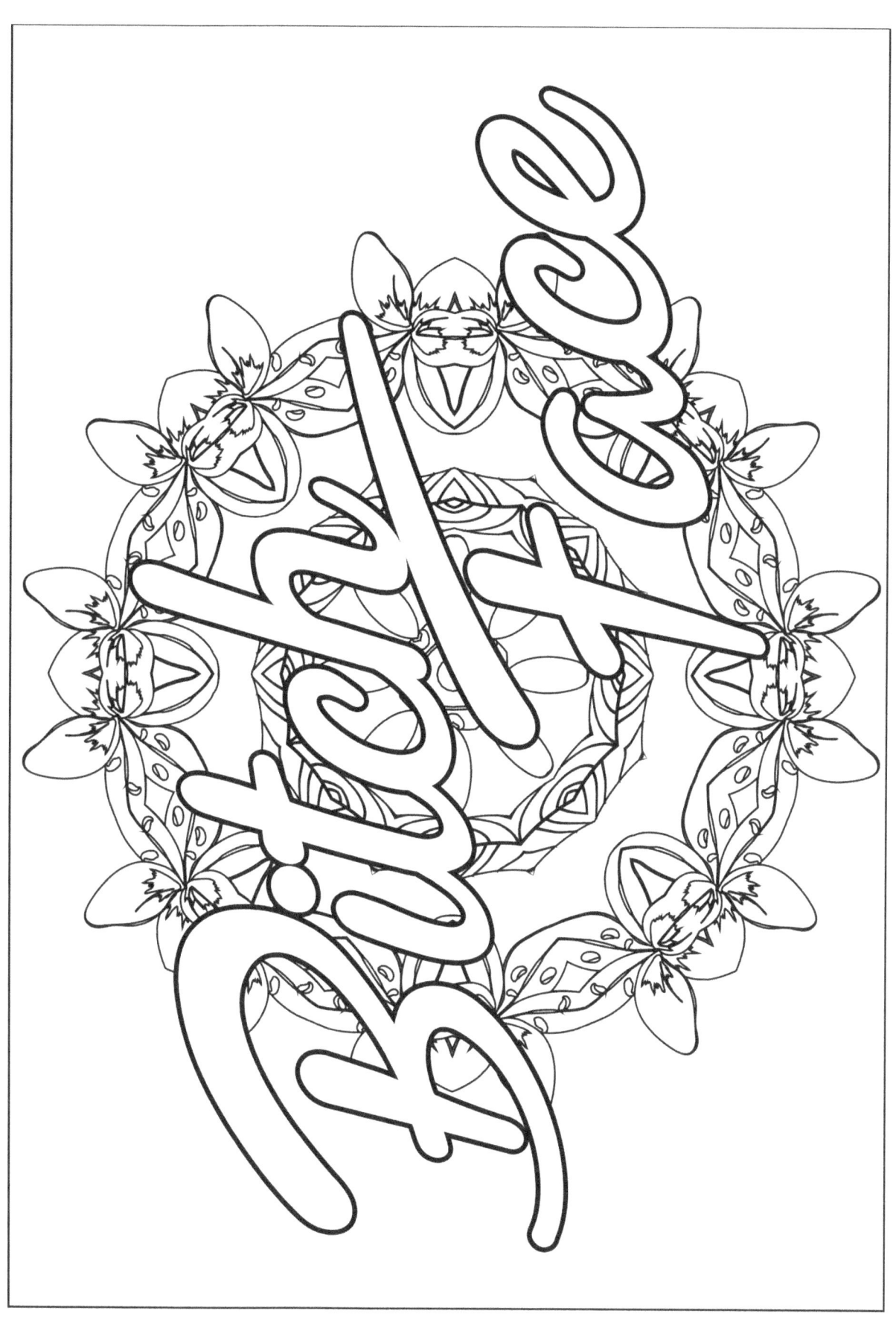

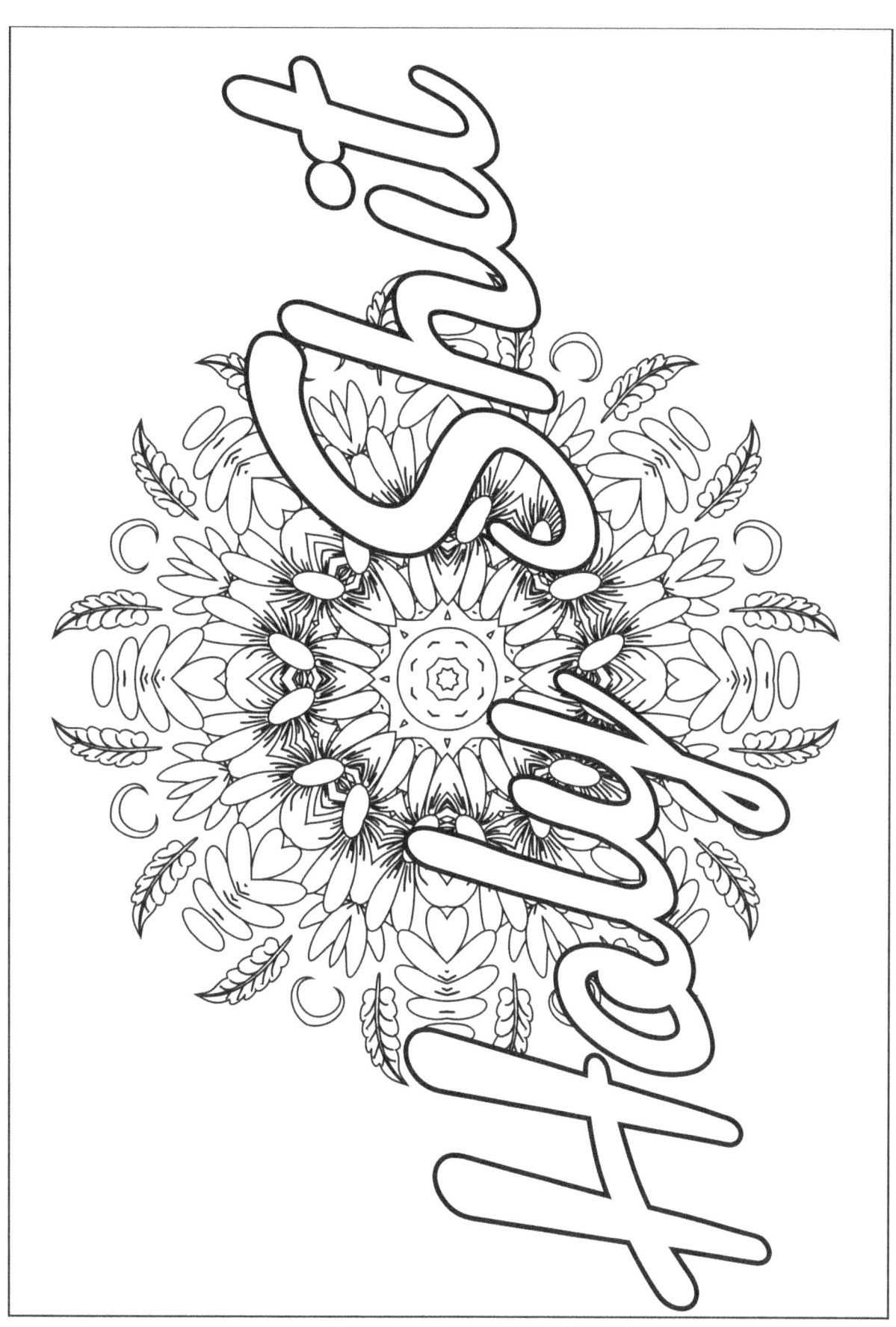

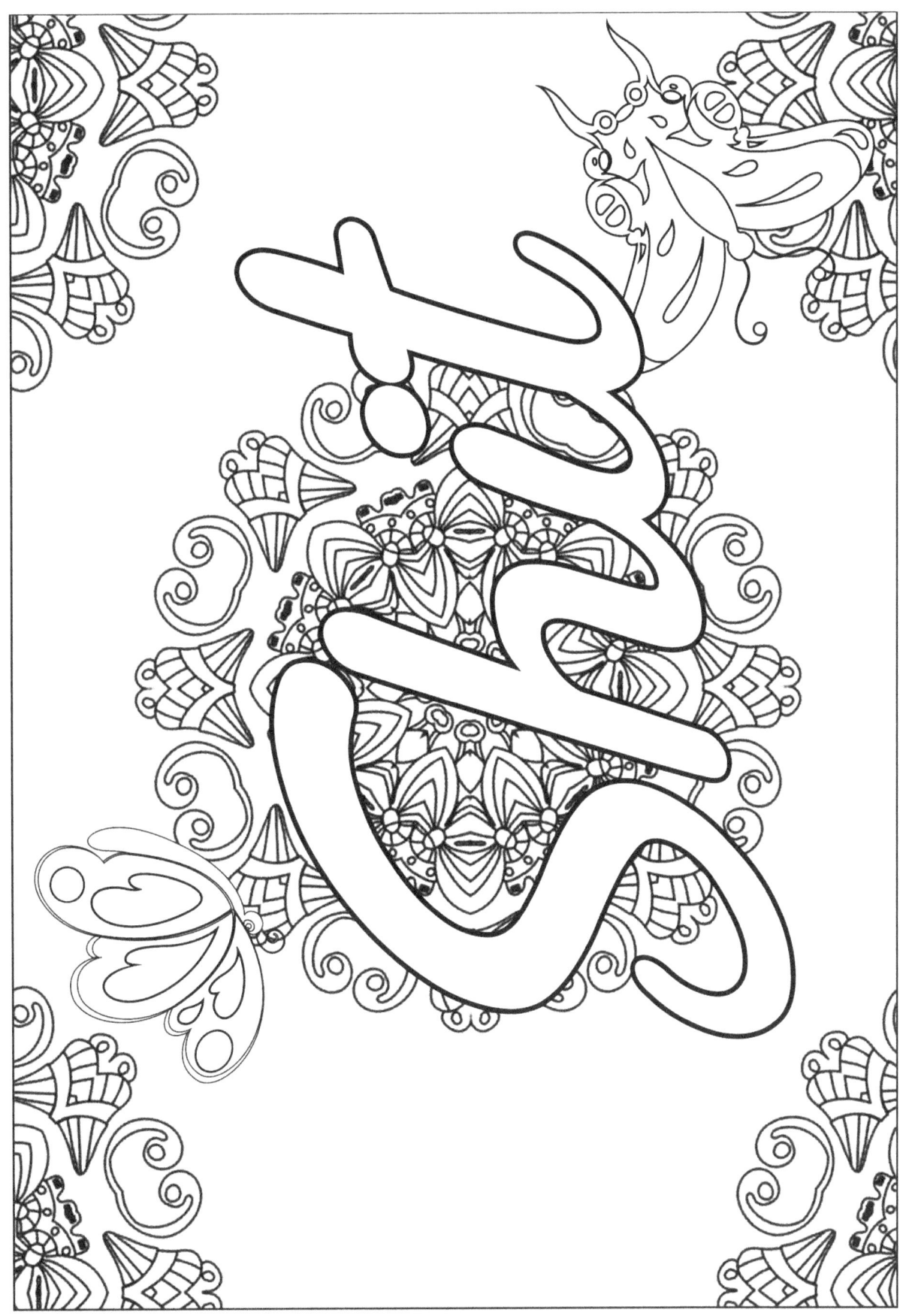

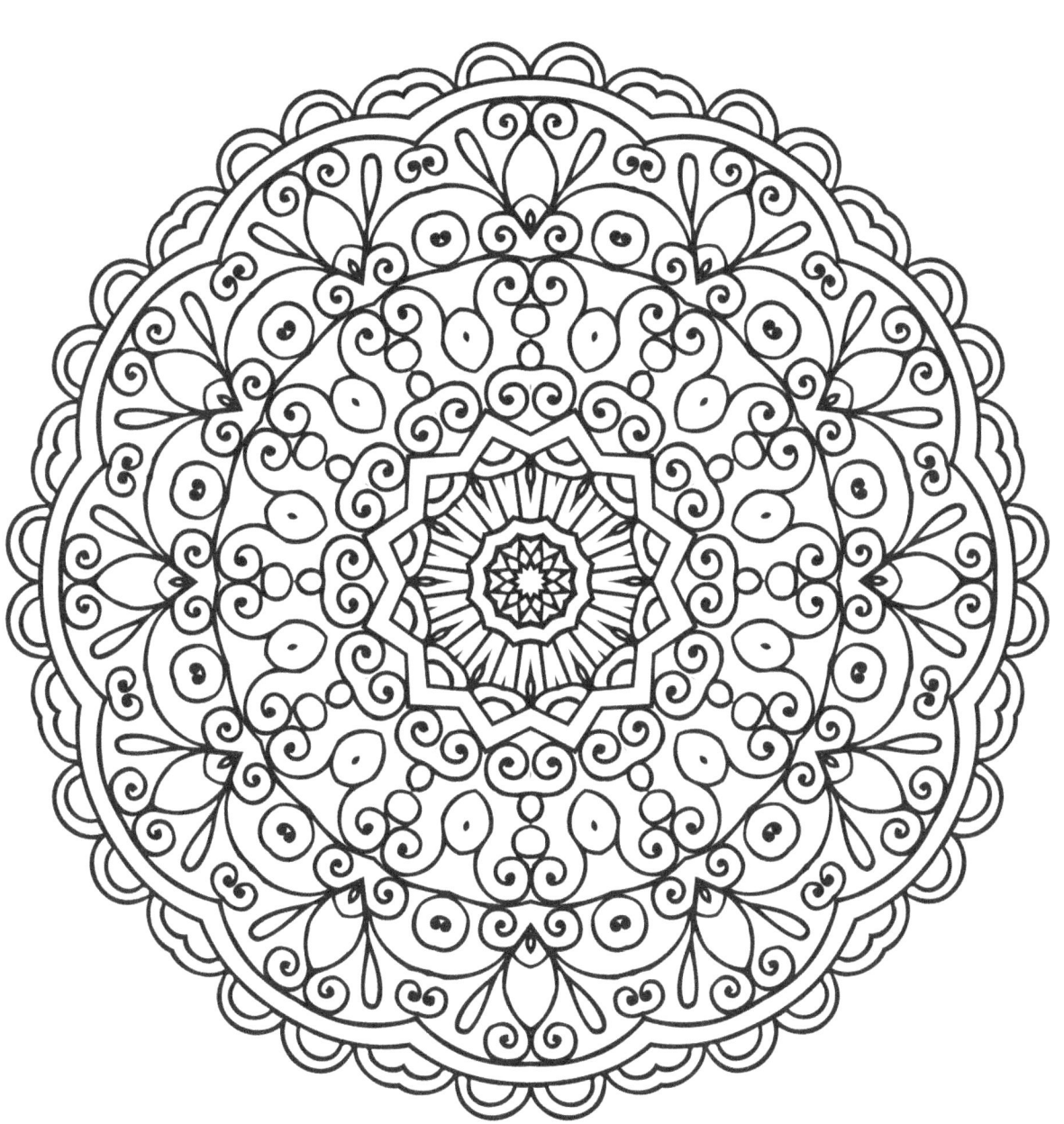

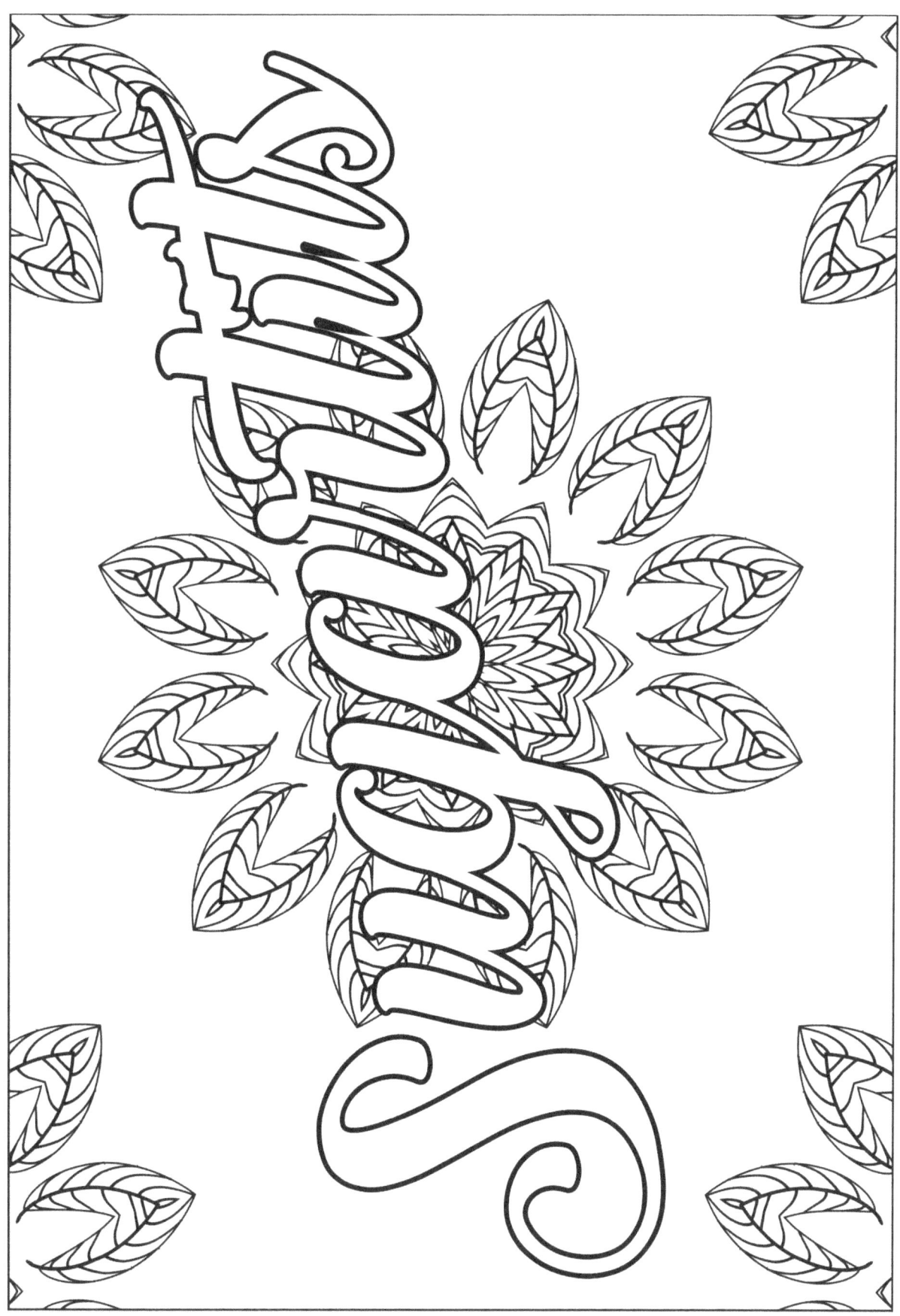

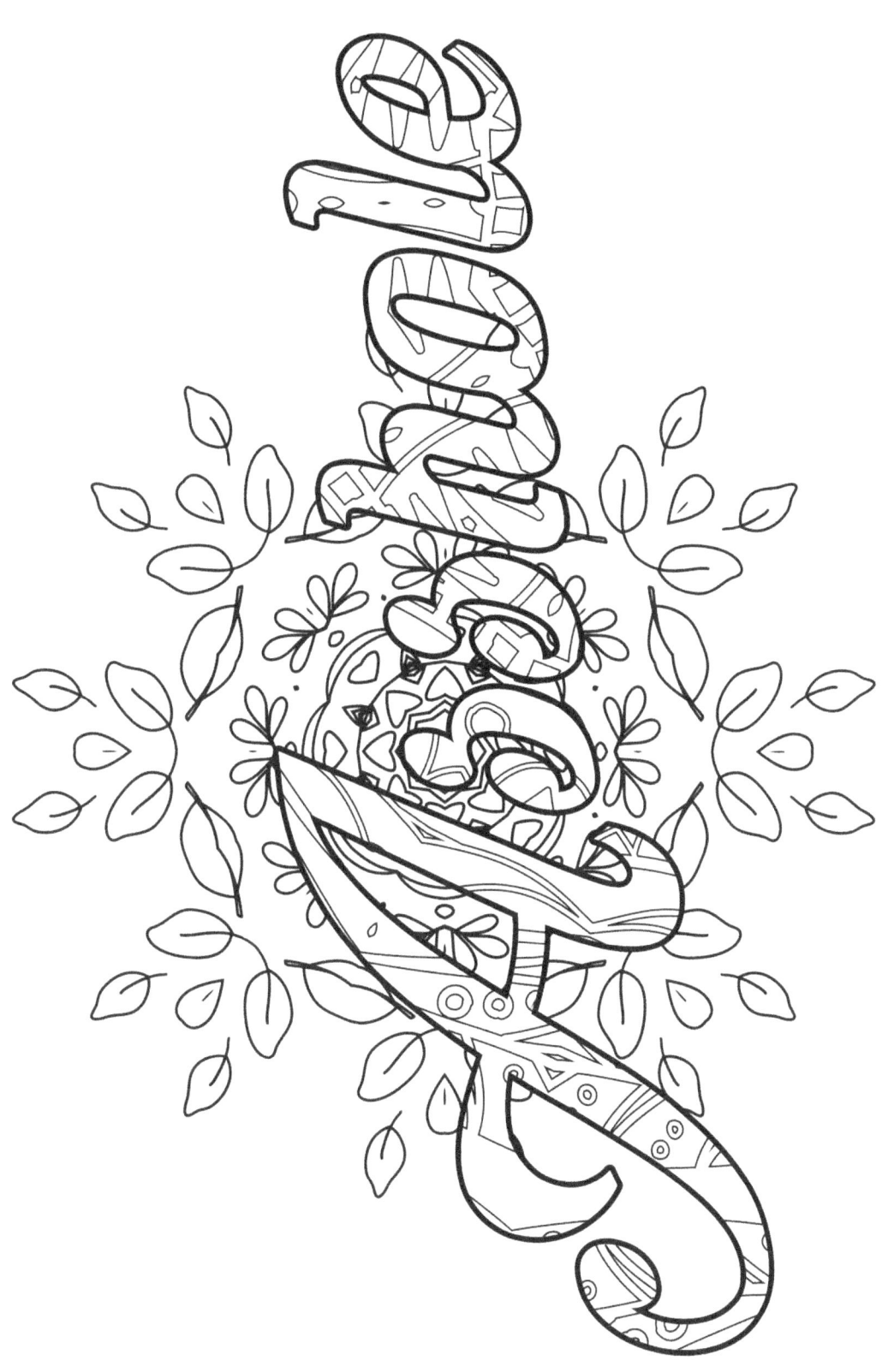

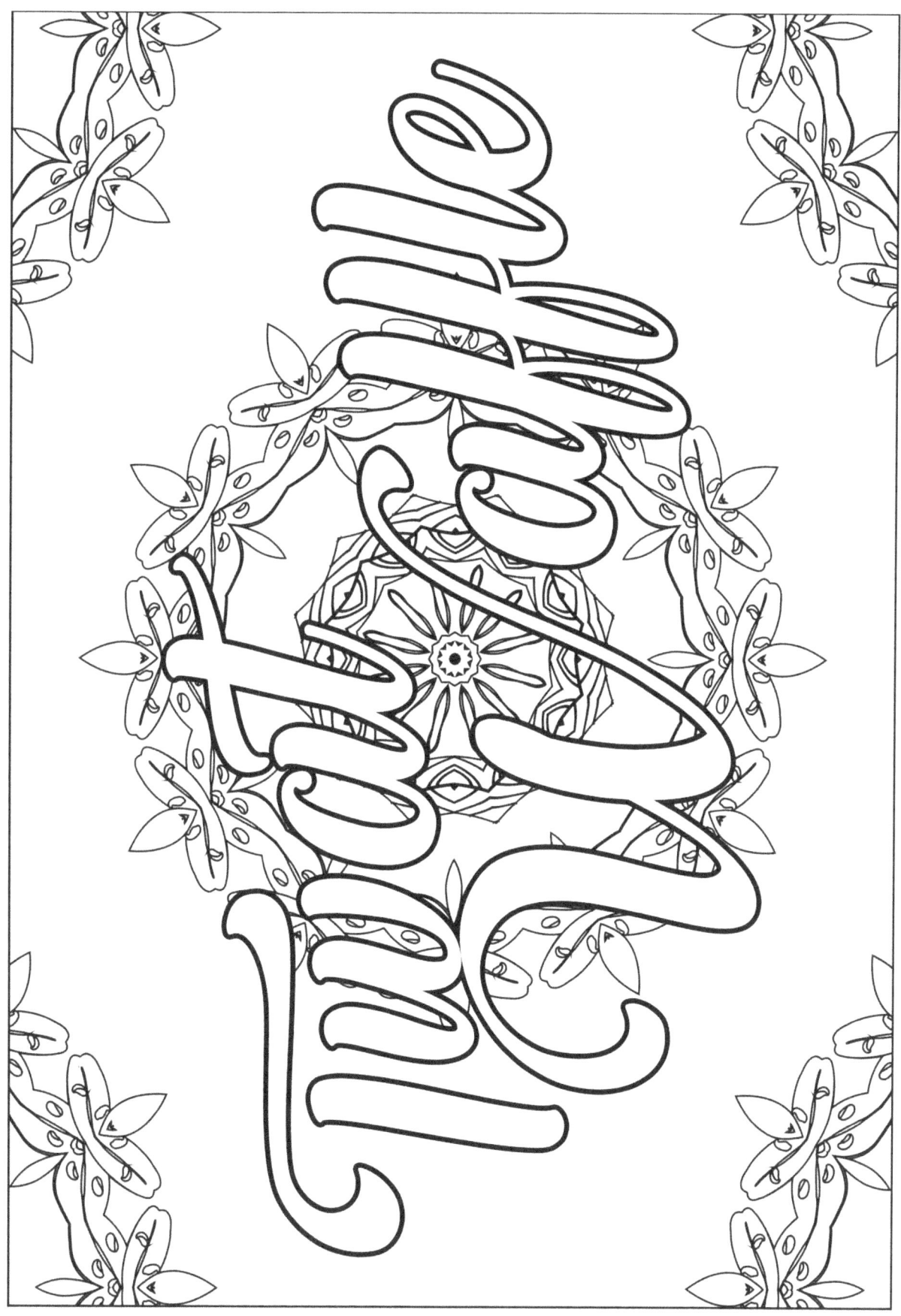

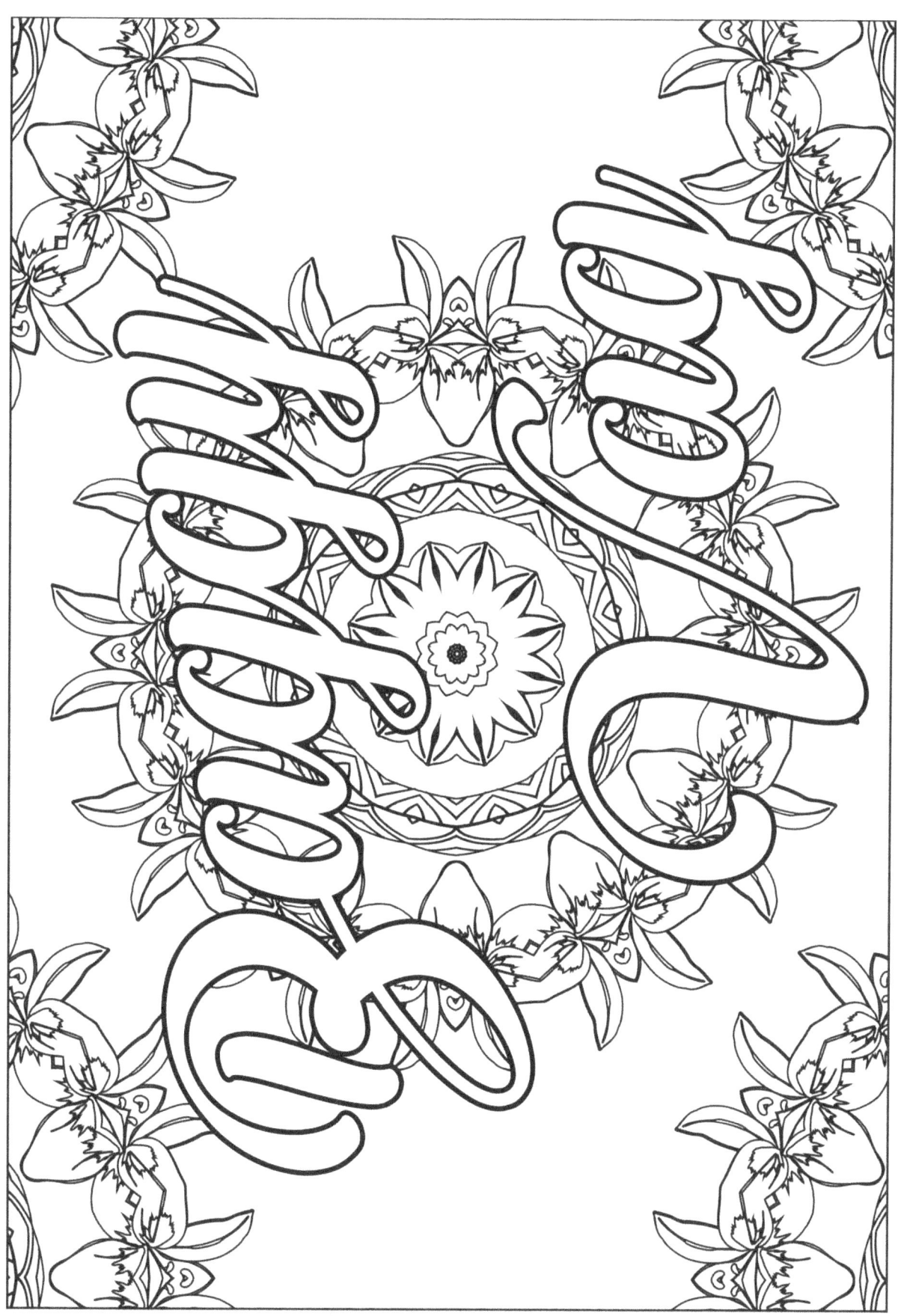

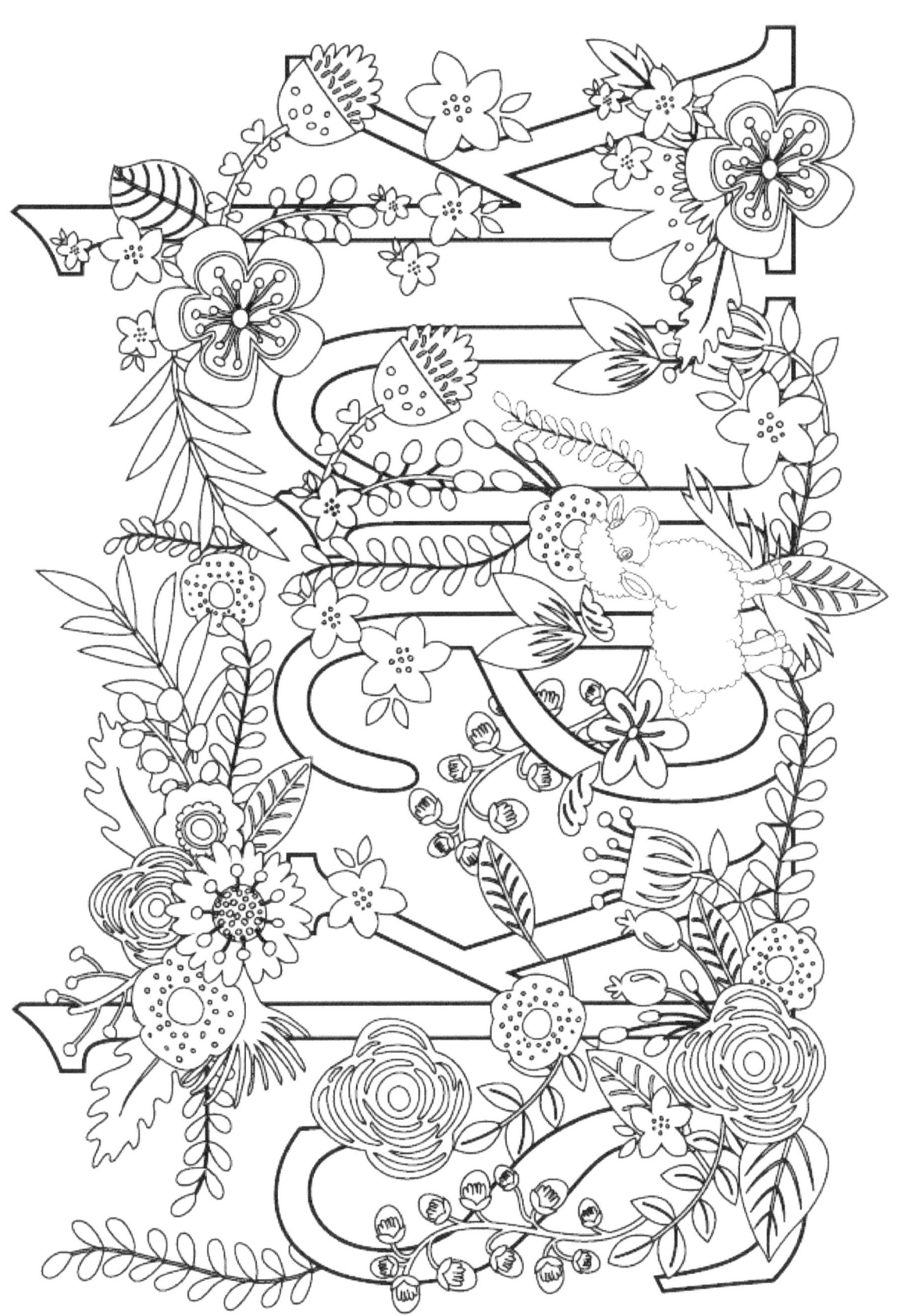

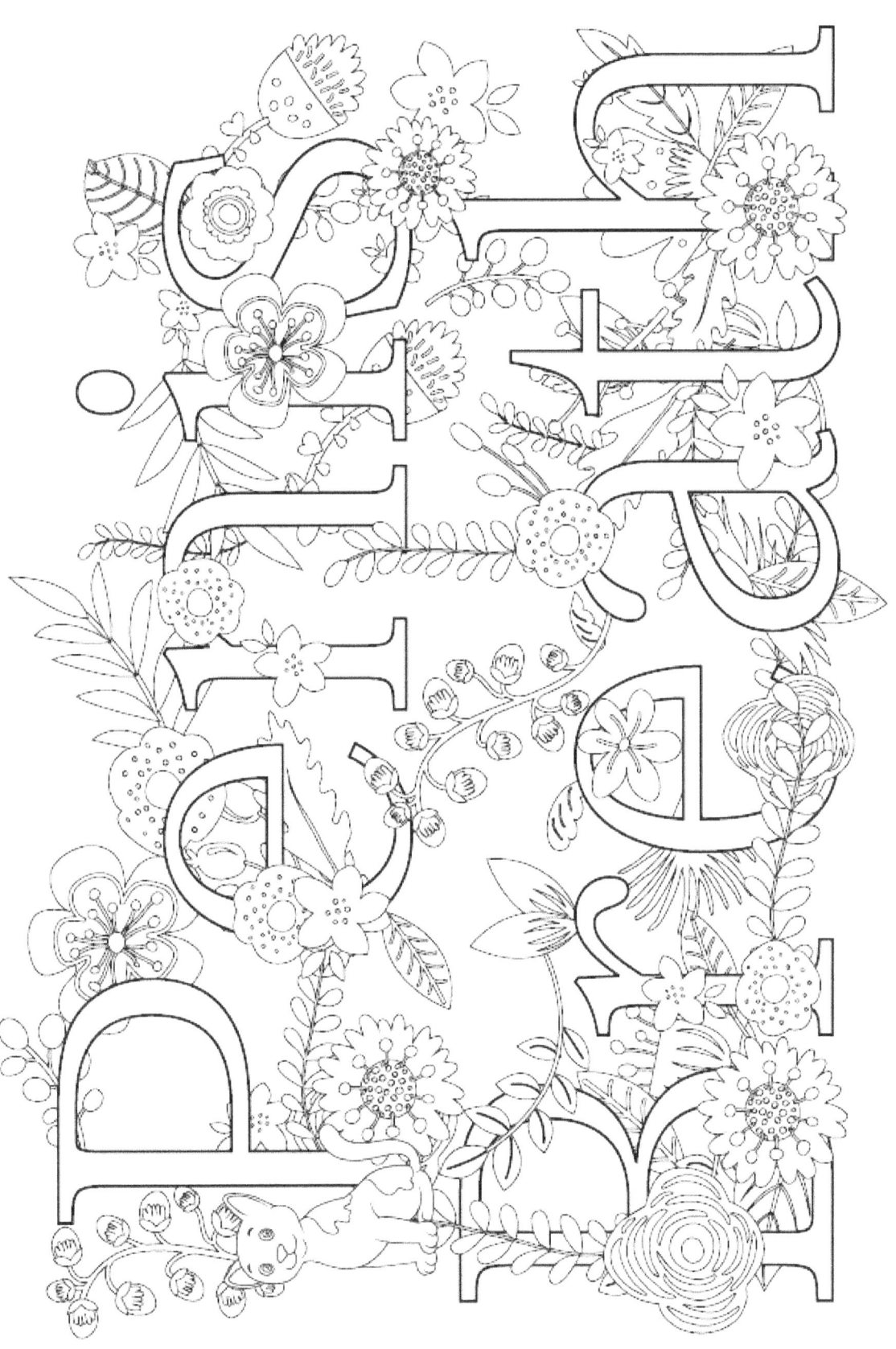

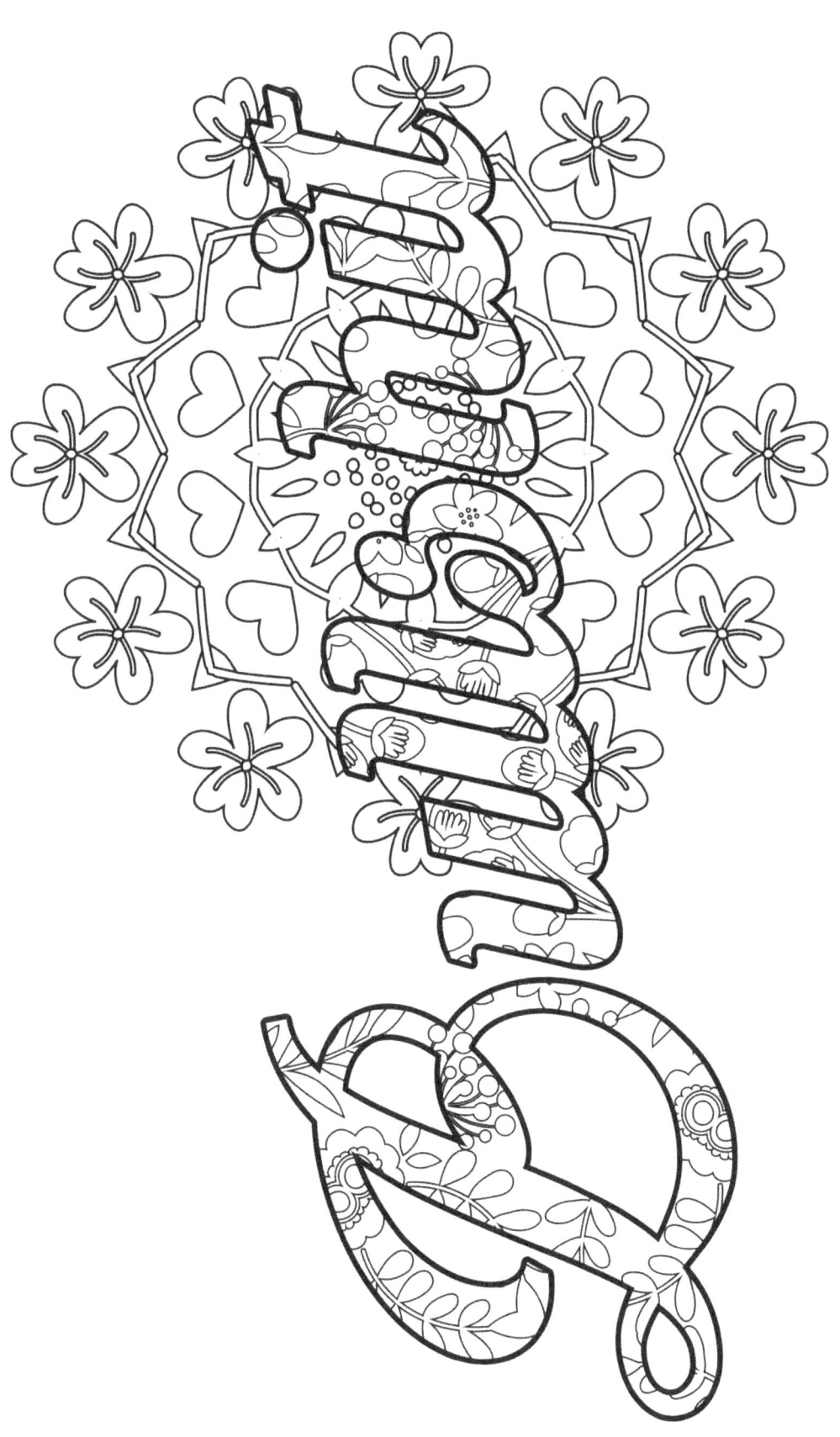

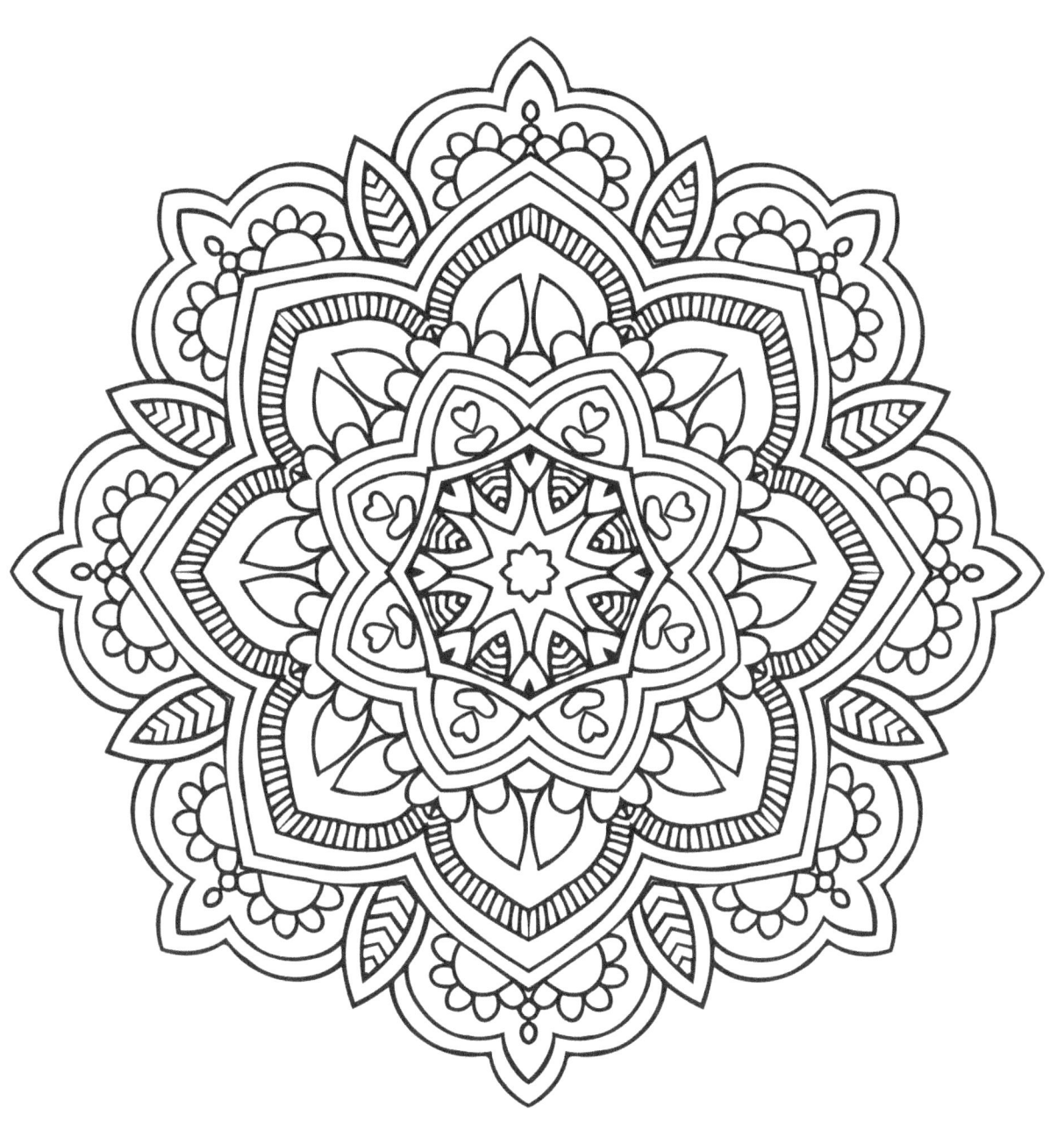

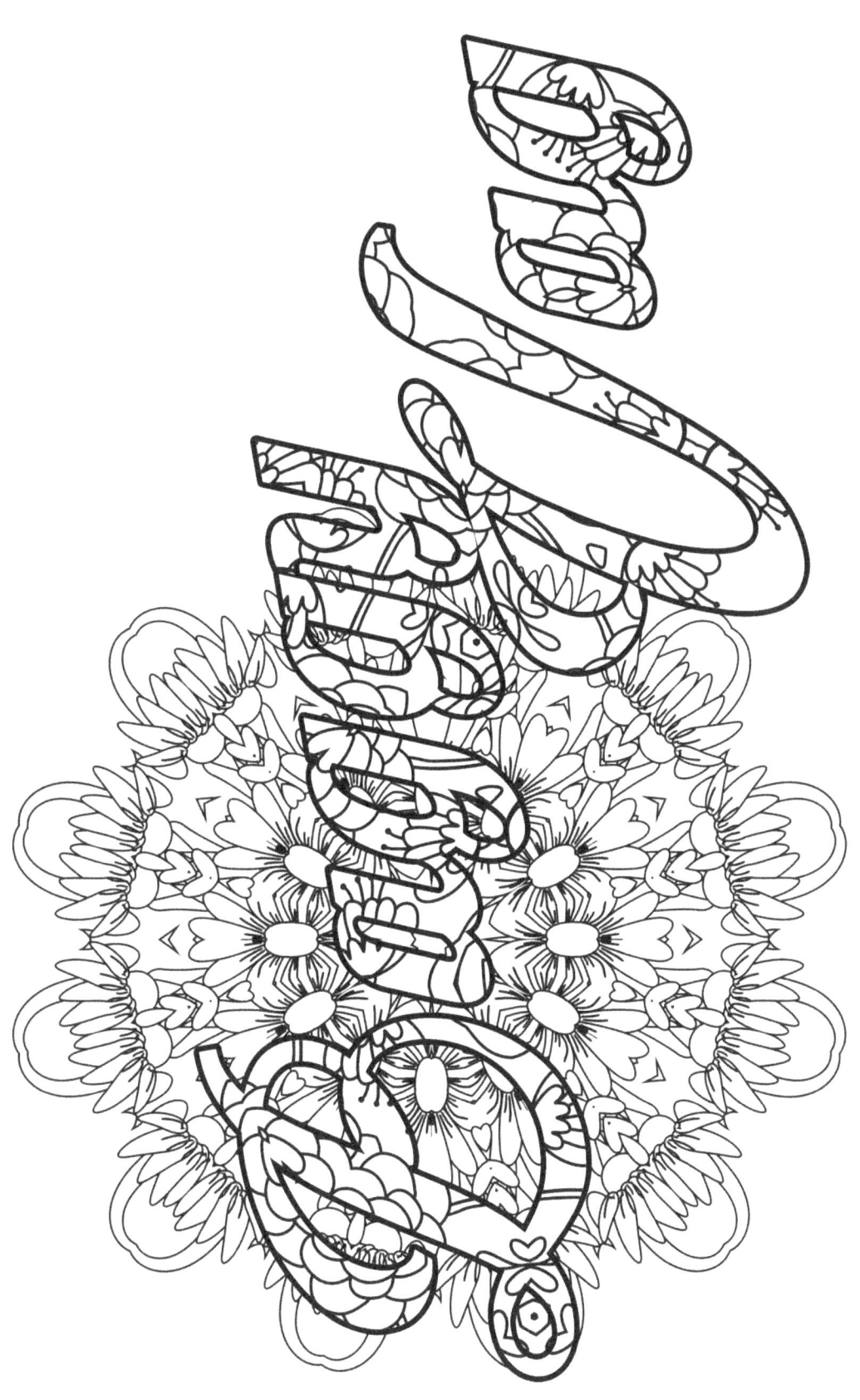

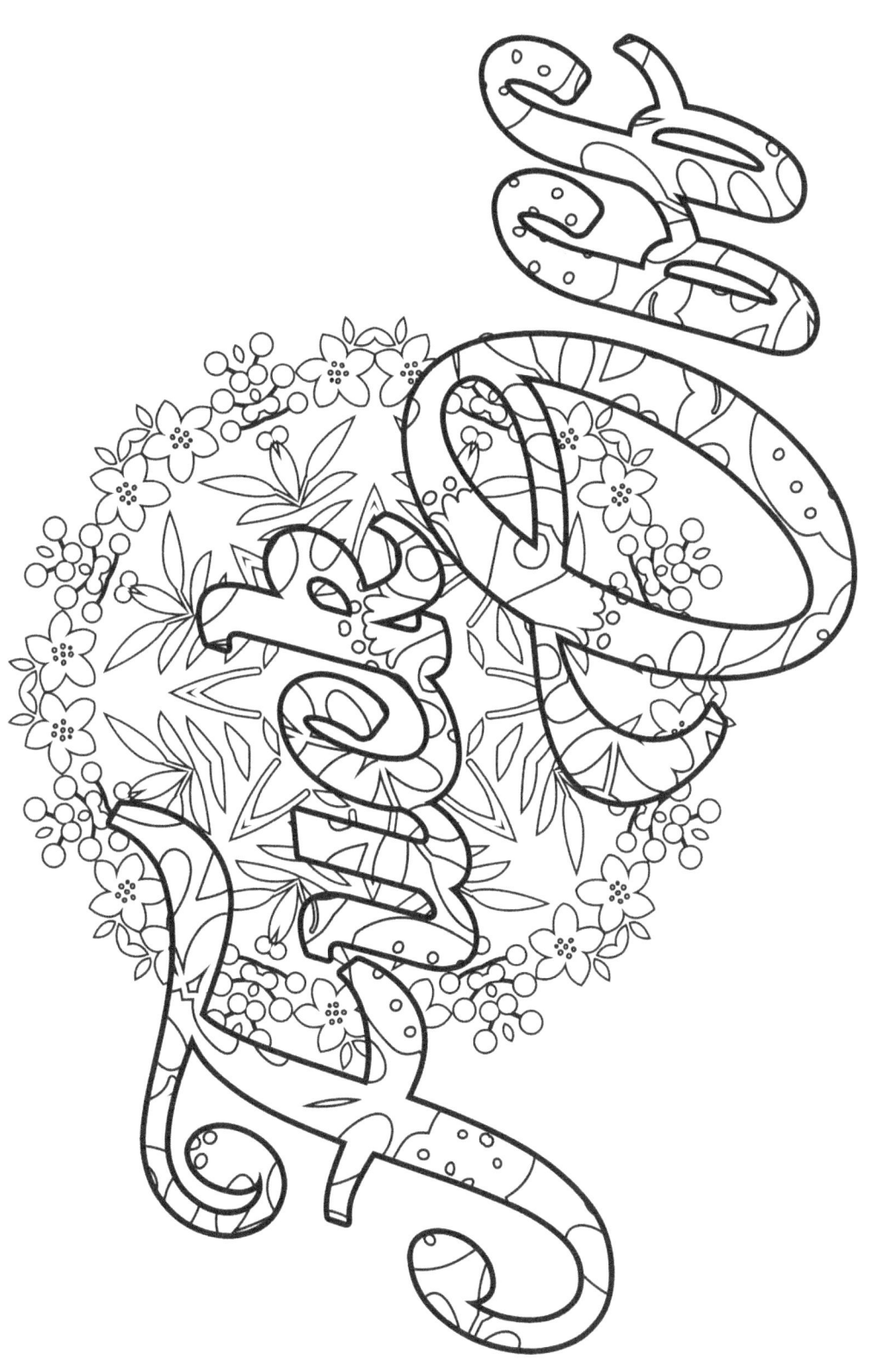

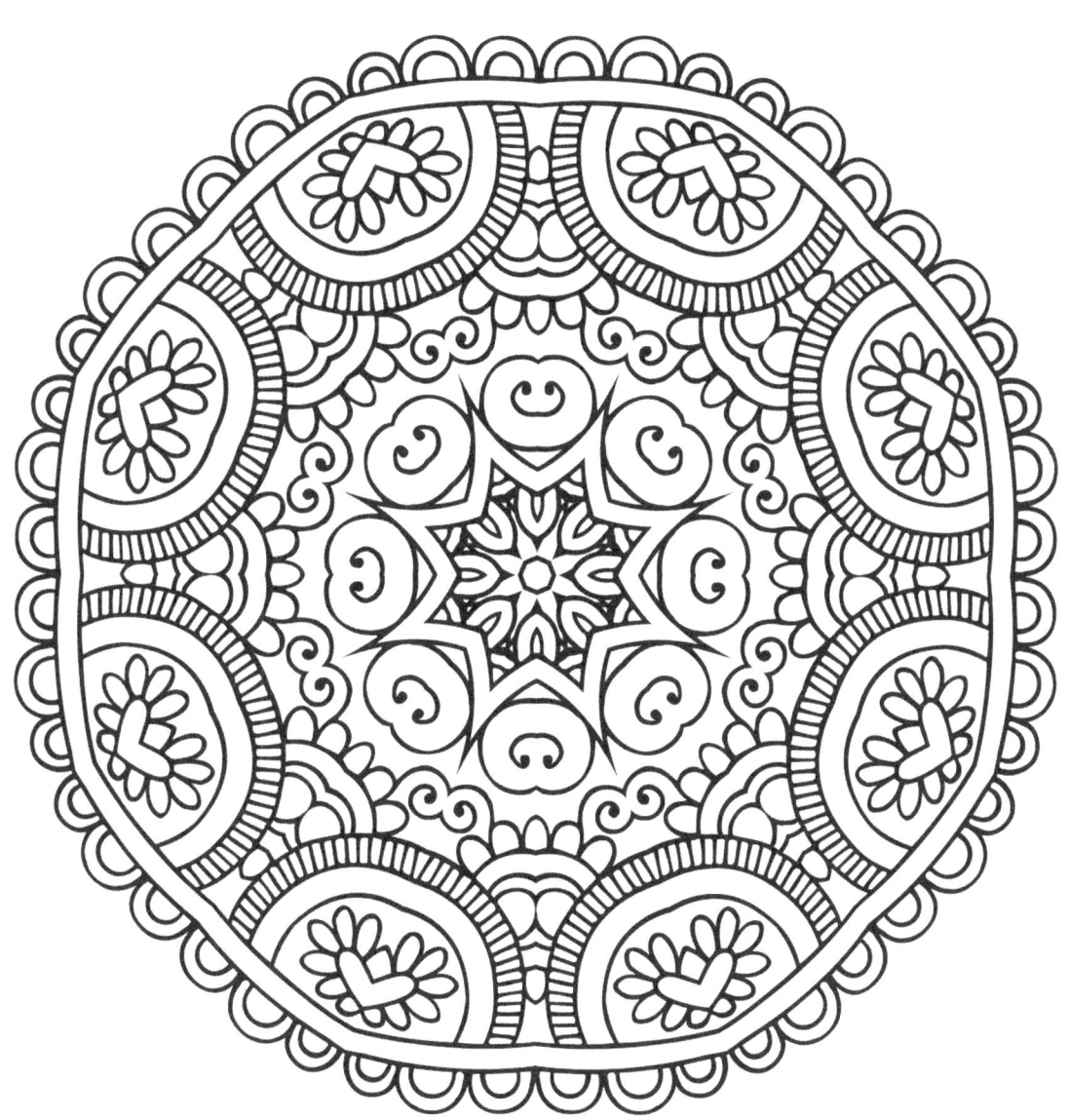

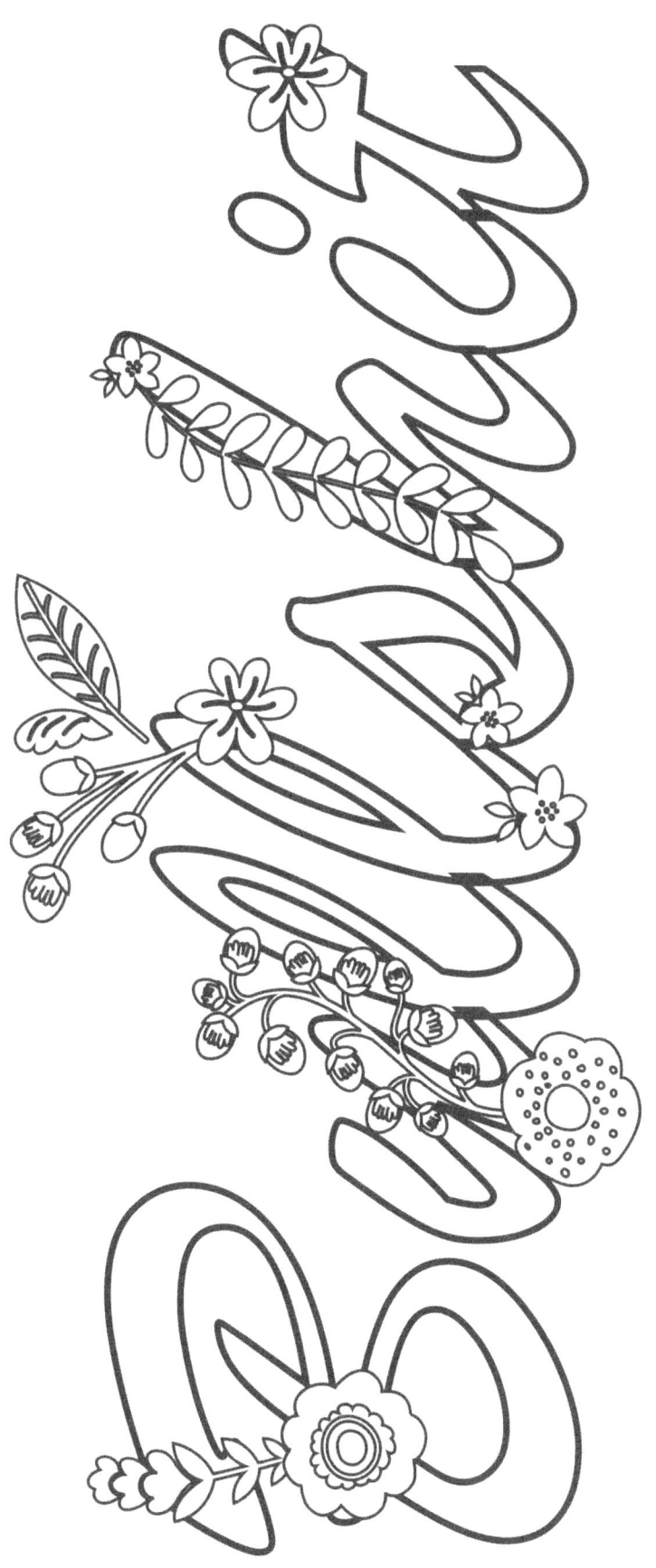

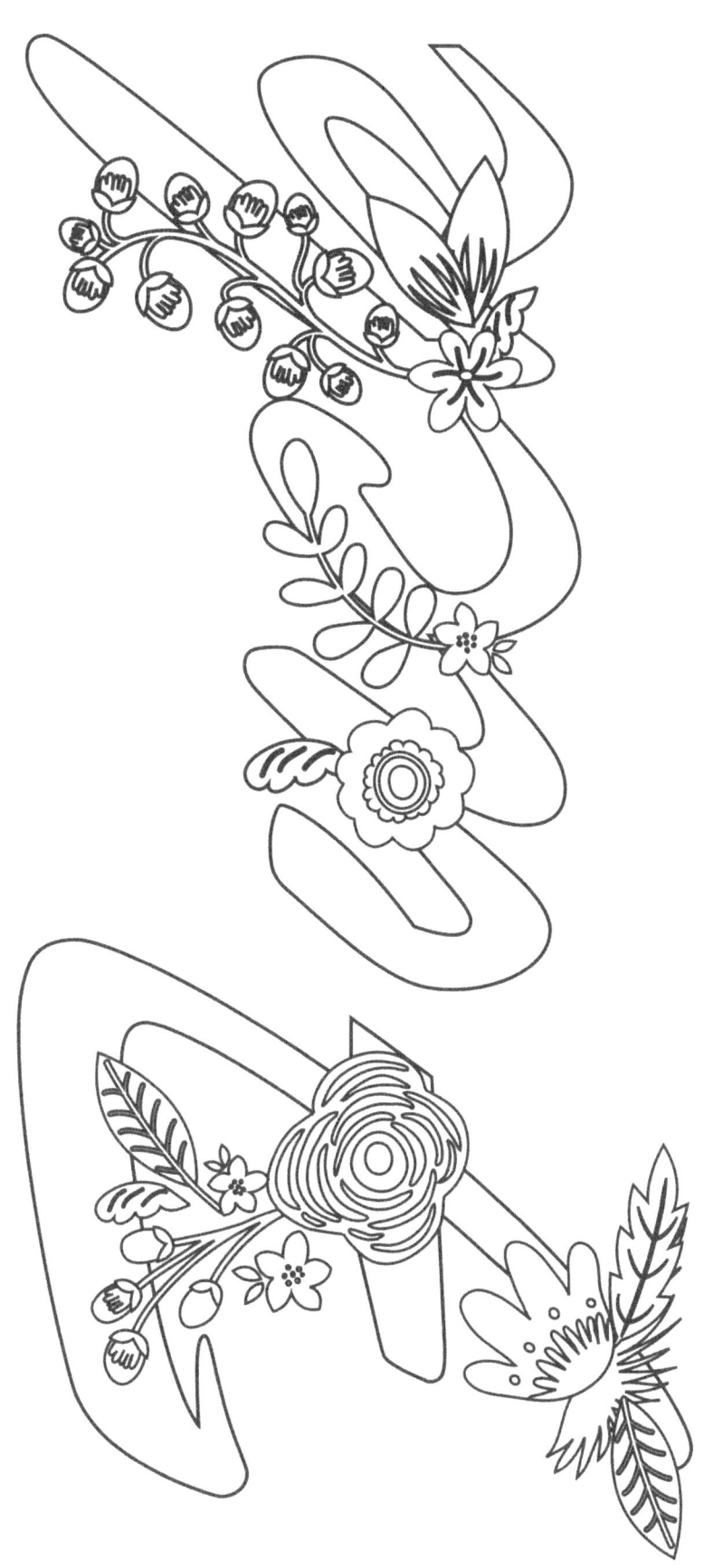

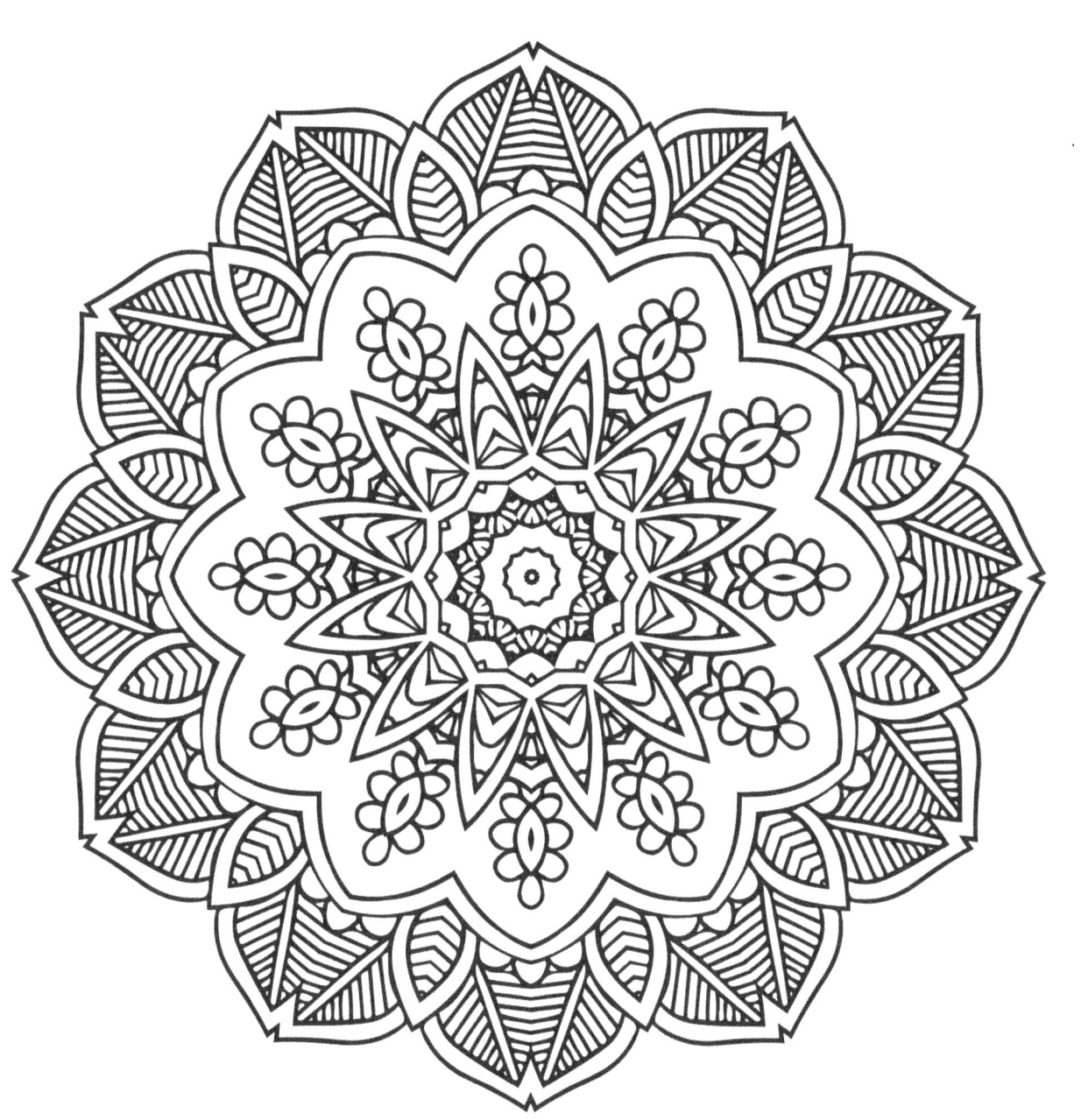

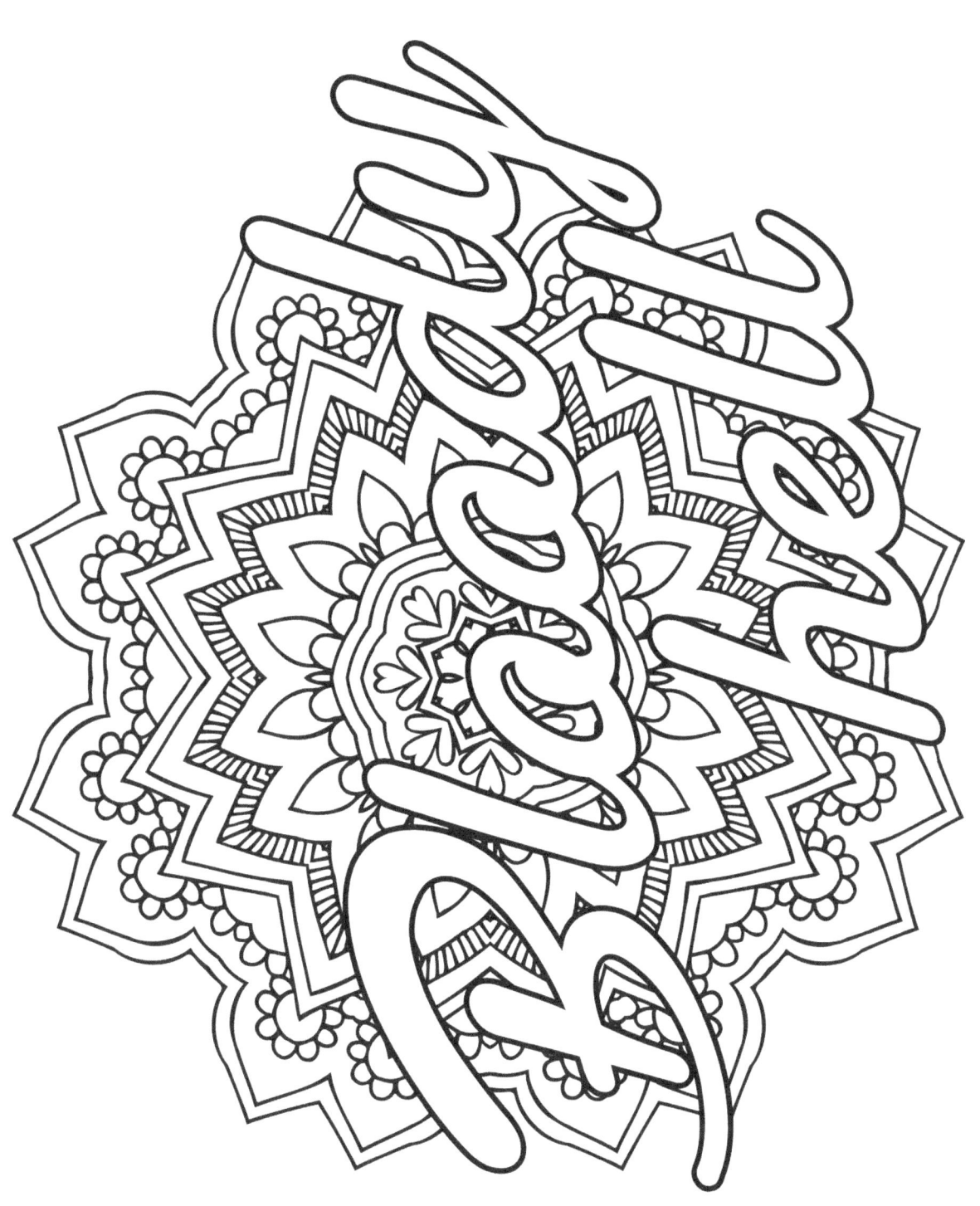

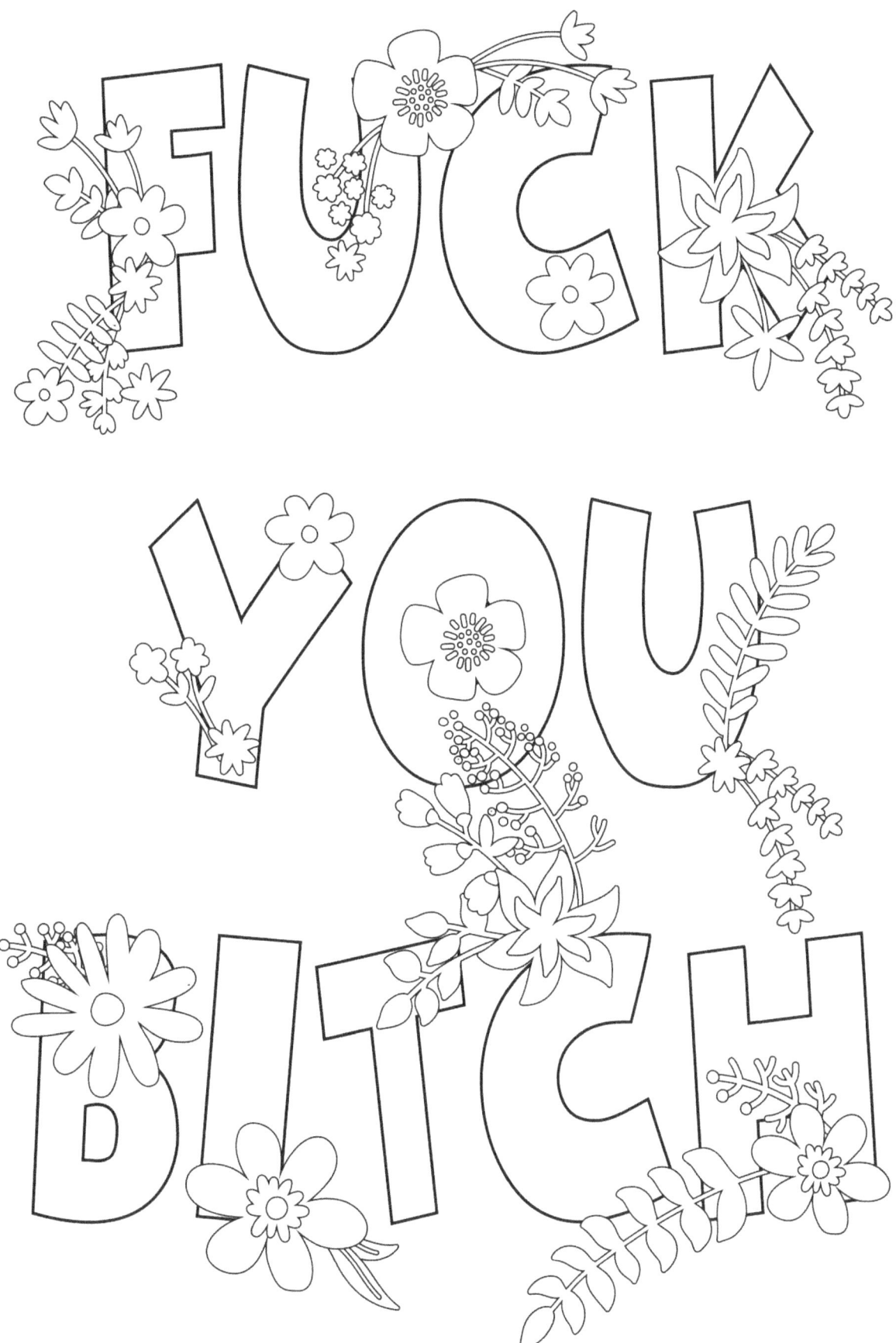

www.ingramcontent.com/pod-product-compliance
Lightning Source LLC
Chambersburg PA
CBHW081253180526
45170CB00007B/2405